1 MONTH OF
FREE
READING

at

www.ForgottenBooks.com

By purchasing this book you are eligible for one month membership to ForgottenBooks.com, giving you unlimited access to our entire collection of over 700,000 titles via our web site and mobile apps.

To claim your free month visit:
www.forgottenbooks.com/free733261

ISBN 978-0-428-98217-1
PIBN 10733261

THE PENNSYLVANIA
MUSEUM BULLETIN

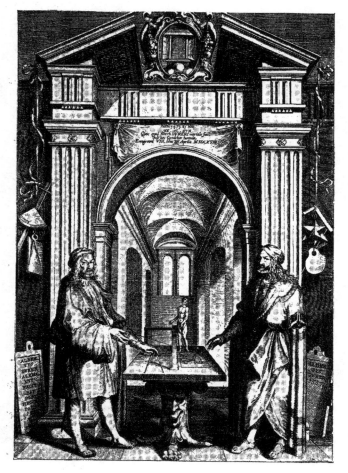

See Page 325

PUBLISHED MONTHLY AT MEMORIAL HALL, FAIRMOUNT PARK
PHILADELPHIA, BY THE PENNSYLVANIA MUSEUM AND SCHOOL OF
INDUSTRIAL ART　　　　No. 110, Vol. XXII　　　　FEBRUARY, 1927

.148
b

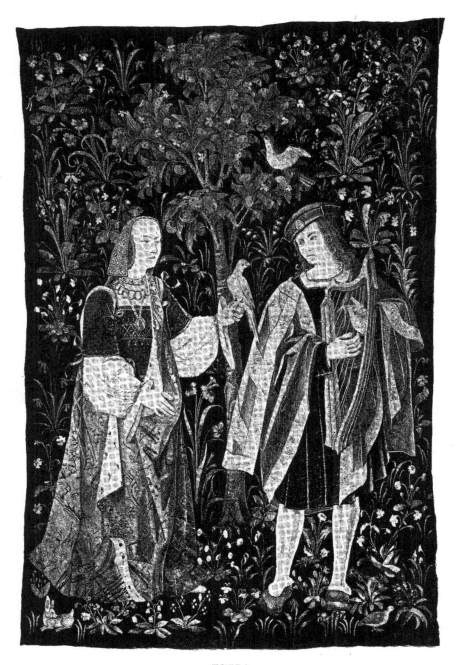

FIGURE 1.
"A SCENE OF COURTLY LIFE." FRENCH TAPESTRY—WOVEN ABOUT 1496.

THE PENNSYLVANIA MUSEUM
BULLETIN

No. 110
VOL. XXII

FEBRUARY
1927

AN EXHIBITION OF TAPESTRIES

An exhibition of tapestries was opened on January twenty-eighth at the Museum with a private view and will continue for the public until April first. It includes examples of weaving from the fifteenth century to the present day, the collections of several friends having been drawn upon to supplement the important Gothic tapestries recently acquired by the Museum together with a selection of later pieces also from the permanent collection.

Few, if in truth any, forms of art offer such manifold opportunities for pure enjoyment as tapestries. In the Gothic period when the limitations of the medium were most faithfully observed, sumptuous colour, rich patterns, distinctive texture and stirring narrative were incorporated into one great whole, preserving at the same time the characteristics essential to a textile. By the second decade of the sixteenth century when the painters of Italy, as well as their itinerant pupils, turned the design toward pictorial themes, the change, though marked, produced tapestries which still satisfied the ideals of the preceding century, owing to the survival of the old loving care in the enrichment of all the parts. The seventeenth century tapestries abandoned the two-dimensional quality in their design, and naturally so, since it was foreign to the spirit of that time. Indeed the colossal figures, theatrically disposed, are the very breath of the baroque movement, vital and romantic, making up in picturesqueness whatever they lacked in subtlety. In the eighteenth century the pendulum has swung once more, and the subject is no longer of consequence. Gone are the allegories and Bible scenes depicted in the grand manner; comedy now furnishes the theme, albeit a slight one, a mere excuse for the exploitation of the decorative ensemble. Small panels set upon a large background, surrounded by woven frames to simulate carved wood were stretched upon walls and incorporated into panelling. Later in the century the tapestries woven after portraits by Boucher led to still further realism in the nineteenth century, until in England the reversion to Gothic principles by Burne Jones and William Morris marked its end. The recent production at the Gobelins, presented to the City of Philadelphia by the French Government, shows a return to the style of the seventeenth century by the appearance of heavy borders of verdure and trophies, and a momumental historic scene filling the center.

This brief introduction will suggest a slight background for the exhibition. To the casual visitor it is a rare experience of glowing colour and varied narrative; to the student it stands as a history of tapestry as it flourished and waned over five centuries, always true to the period from which it sprang, if less faithful to the principles of the craft.

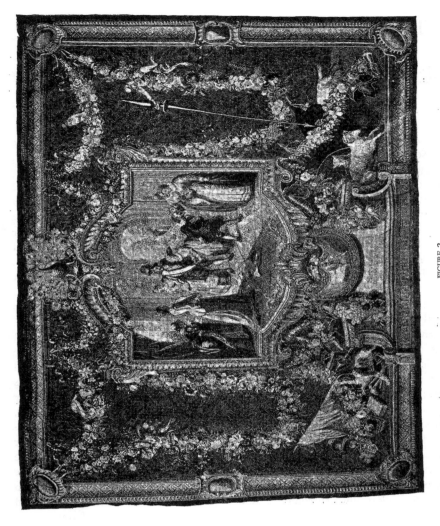

FIGURE 2.
"DON QUIXOTE SERVED BY THE LADIES." GOBELINS TAPESTRY—WOVEN IN 1773.

The earliest tapestries have been hung in the foyer, a Tournai example woven about 1475 claiming first place in the chronological arrangement. It is known as "Espérance" by the appearance of that word in the design, and gives evidence of the naïve charm of early tapestries produced by the lack of reality and the use of conventional forms to express an idea. This piece is the gift of Sir Joseph Duveen. The second example, lent by the donor of the first, dates perhaps ten years later and was also woven at Tournai. All the delightful details significant of Gothic times are here—the turreted castles, lords and ladies richly garbed, sprightly animals of the chase and flowering plants and trees, drawn with considerable zest, and presented with a sincerity and directness unequalled in any subsequent time.

A "Scene of Courtly Life" (Figure 1) is the most recent tapestry to be acquired by the Museum and until lately formed a part of the Kaubach Collection in Vienna. It is of the same series as the set of six tapestries in the Cluny Museum in Paris that were woven in Touraine, at the end of the fifteenth century. Against a dark blue ground scattered with flowering plants stands a lady of the *moyen age* wearing a brocaded velvet-ermine-lined cloak that reveals only the upper portion of her costume. A bird, perhaps a falcon, perches upon her left hand, and turns an inquiring eye toward the lord nearby who lightly touches the strings of his harp. Overhead another bird flutters amongst the fruit-laden branches of a tree. Pleasing in colour and poetic in theme, this tapestry must be counted as a possession of first importance on account of its early date, high quality and present splendid condition.

The "Deposition from the Cross" woven in Brussels about 1510, is the last of the Gothic group; in fact the Renaissance spirit is already apparent within it. Here are the rose-and-grape border, architectural formulas and flower-bestrewn ground, but the close-knit composition of the figures and the rather greater naturalism of their faces indicate the influence of the painters' that, with Raphael's cartoons five years later, overwhelmed the Gothic tradition.

A fine expression of early sixteenth century Brussels' work is lent by the Estate of the late Charles M. Ffoulke. The subject is "The Roman General Curius Dentatus Refusing the Gifts of the Samnite Ambassadors." The background shows a pastoral scene, and flowers, fruits, cupids and satyrs are combined to form the border. A golden colour prevails throughout, although the rich reds and blues common to earlier years are introduced into the costumes. "Joseph's Brethren Selling Him to the Ishmaelites" must be placed later in the same century, after 1525, since it bears the double B with a shield in its border, the mark of Brussels, together with a weaver's mark. Six pieces of the "Moses and Aaron" series from the looms of Brussels during the first half of the sixteenth century are attributed, by means of the monogram on three of them, to Pierre Van Aelst, who, it will be remembered, wove the famous "Acts of Apostles" set from the cartoons of Raphael. The masterly drawing of the figures and the fine organization of the composition, is supplemented by a

pervading warmth of colour to represent adequately the Renaissance period. The subjects are "Moses and Zipporah," "Moses Informing Aaron of God's Message," "Moses and Aaron Instituting the Feast of the Passover," "Moses Receiving the Tablets on Mount Sinai," "The Battle of Rephidim" and "The Gathering of Manna." The borders are again occupied by birds, fruits and flowers; female figures mark the corners, while vistas of landscape and architecture fill the background. These seven tapestries are lent by the Estate of the late Charles M. Ffoulke.

The seventeenth century is represented by several Flemish examples, four in the Bloomfield Moore Collection owned by the Museum, illustrating the "Story of Jacob,"[1] and one representative piece "The Family of Darius at the Feet of Alexander" lent by Mr. and Mrs. James F. Sullivan. It is signed by Jan Leyniers, one of a family noted as weavers since the sixteenth century. This episode from one of the "Nine Heroes" is depicted with all the breadth and style of the mid-seventeenth century, the patterned garments of the bold figures and details of the background contributing no little toward the decorative effect when the tapestry, falling in folds, makes a demand upon every portion of the surface to furnish some interest.

The early eighteenth century is represented by two tapestries lent by the Estates of the late Charles M. Ffoulke and Sarah C. Ffoulke. "The Triumphal March of Charles V" was woven at Malgrange near Nancy by weavers who were sent from the Gobelins manufactory at the request of Duke Leopold of Lorraine. The clear green, deep blue and brilliant red were produced under the direction of Van de Kerchove, the most successful superintendent of the Gobelins. The scene represents a procession showing Charles V enthroned upon a chariot with four allegorical figures at either corner typifying Asia, Africa, Europe and America. The border is in the form of a picture-frame, bearing heraldic devices. The second tapestry is one of the Months of Lucas, "The Vintage," copied at the Gobelins from the Flemish sixteenth century series, and named from Lucas Van Leyden, who was mistakenly accredited with their design. Such genre scenes were inspired by the little Dutch masters and so great was their favour that the same subjects were woven repeatedly.

The second half of the eighteenth century brings us to the magnificent set of five Gobelins tapestries, the "Don Quixote" series, lent by Mr. and Mrs. Fitz Eugene Dixon. The scenes are, first, "Don Quixote Guided by Folly," signed Neilson ex 1783; second, "Don Quixote Misled by Sancho, Mistakes a Peasant Girl for his Dulcinea," signed Cozette, 1773; third, "Don Quixote Asks Permission to Address the Duchess," signed Cozzette, (sic) 1773; fourth, "Don Quixote Served by the Ladies," signed Cozette, 1773 (Figure 2); fifth, "Sancho Departs for the Island of Barataria," signed Audran, 1773.

The history of this set of tapestries is well known. Four of them were presented in 1774 to the Archbishop of Reims by Louis XVI and subsequently were sold in Paris after the death of the prelate. The fifth piece, which is

[1] Loan Exhibition of Tapestries, by George Leland Hunter, Pennsylvania Museum, 1915.

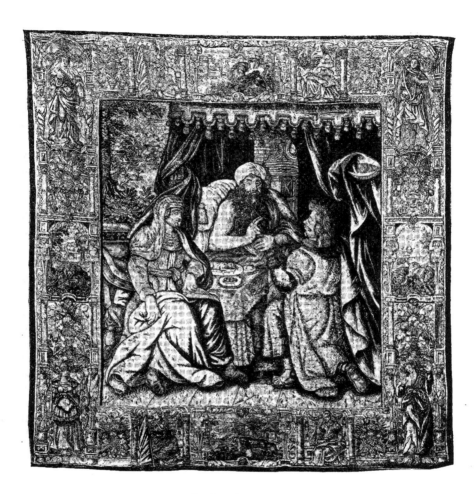

"ISAAC BLESSING JACOB."
FLEMISH EARLY 17TH CENTURY

number one of the set, was given to the Duke of Hesse-Darmstadt by Napoleon in 1810. All five tapestries were bought by the King of Spain in 1883 and remained in the Royal collection until early in the present century, when they were acquired for the J. Pierpont Morgan collection.

Charles Coypel painted twenty-eight scenes from Cervantes' Don Quixote between 1716 and 1751. The engravings from these paintings served innumerable times as models for the tapestry weavers of the Gobelins, this subject having the facile adaptability to a set of many or a few pieces. The crimson, leafy ground appeared for the first time in 1760 under the hand of Jacques, who discarded the yellow mosaic *alentour* used heretofore by Fontenay and Audran. The garlands of flowers were designed by Tessier, and Desportes painted the cartoons for the sheep, dogs, monkeys and peacock. Double frames in two tones of yellow are woven in chiaroscuro to frame the picture.

One may well ask how the spirit of the declining eighteenth century could be more adequately expressed than by the Don Quixote subject, its superb execution and exquisite colouring. Elegant, brilliant and amusing, these tapestries met the exactions of their time in a manner as logical and as satisfying as did those of the Gothic period and remain as a criterion of the civilization from which they came. JOSEPH DOWNS

AN EXHIBITION OF EARLY ITALIAN ENGRAVINGS

Through the generosity of Mr. and Mrs. Charles M. Lea, of Devon, we are able to exhibit from January 28th to April first a collection of ninety-five Italian engravings and wood cuts. Last spring we showed in our galleries a group of paintings once a part of the collection of Dr. Isaac Lea. His son, the late Henry Charles Lea, eminent as an historian, continued the tradition thus established in the family, and formed a valuable collection of engravings of a comprehensive character with several hundred prints, embracing all the schools. This was a generation ago when prints by the old masters were less rare than today, so that Mr. Lea, with great foresight and judgment, was able to accumulate examples which would now be well nigh impossible to obtain. Most of these were inherited by Mr. Charles M. Lea, who, from time to time, added to the collection.

Practically the whole range of the art of engraving in Italy is represented in this exhibition. A list which includes Mantegna, Raimondi, Montagna, Giorgio Ghisi, the Carraccis and Tiepolo is alone indicative of the importance of the collection. If the name of Pollaiuolo (1432–1498) is omitted, it must be recollected that only one absolutely known example of this master's work exists, namely, "The Battle of the Nudes." Pollaiuolo's style, however, is reflected in "Hercules Strangling Antæus" by Giovanni Antonio da Brescia (flourished about 1502–1512) after Mantegna, the subject definitely derived from drawings and bronzes by Pollaiuolo. The School of Maso Finiguerra (1426–1464) is represented by a small niello print. Many have thought that these little prints, taken from small silver or gold incised plates where the

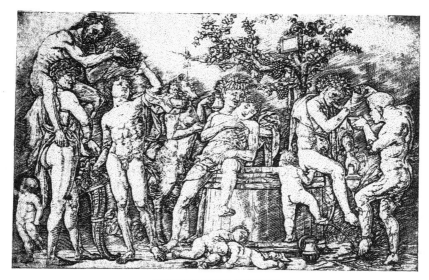

BACCHANAL OF THE WINE PRESS
BY ANDREA MANTEGNA

intaglio was filled in with a black substance called nigellum (hence the word "niello") and used for ornamental purposes, were the forerunners of engravings, but we do not know of any before 1450, whereas in Germany, where the art of niello was unknown, engraving was practiced somewhat earlier. The tiny niello, "Adoration," is the earliest print in our exhibition and shows the extreme delicacy of the primitive Florentine School.

Compared to the early German engravers, like Dürer and Schöngauer, the Italians were superior in the treatment of form: they possessed more idealism, poetry and imagination. It is true they were inferior technically. The Northern masters excelled in line and design. The art of engraving, like that of printing, seems to have been the natural gift of the Northern race. It was admitted by the Italians of his day that Dürer was the greatest master of line.

The influence of Dürer on Italy was most pronounced on Marc Antonio Raimondi (ab. 1480–ab. 1530), one of the greatest of all engravers. In the Lea collection are exhibited Marc Antonio's complete series of engraved plates after Dürer's wood cuts of the "Life of the Virgin." It is to be noted that this is, in a sense, a translation from one technique to another, and it is remarkable that we are able to exhibit the complete set. Other prints in Marc Antonio's own style in the collection are "Mars and Venus" and "David and Goliath." The former is especially distinguished for purity of line and depth of shadow.

The great painter Andrea Mantegna (1431–1506) ranks scarcely second to that of Marc Antonio Raimondi, as an engraver. A classicist, with a profound feeling for form as well as a clear sense of line and design, which latter is especially shown in his treatment of draperies, he was as great an influence on

the art of engraving as he was on that of painting. Only seven or eight plates are definitely attributed to Mantegna and of these four are included in the exhibition, namely, "The Entombment," "The Resurrection," "Bacchanal with the Wine Press," and "Battle of The Tritons and Sea Gods."

Of the contemporaries of Mantegna represented in our collection, Cristofano Robetta (1462–1522) is one of the most attractive. "The Adoration" is a charming adaptation of Filippino Lippi's picture in the Uffizi gallery, Florence, and indicates a transition from the primitive manner to the high Renaissance. Benedetto Montagna (about 1470–after 1540), however, quite belongs to the new period ushered in by Giovanni Bellini and Giorgione, who sought in the classical allegories of such Roman poets as Ovid and Virgil, themes for poetic fantasies. Montagna's print in our exhibition, simply entitled "Youth Sitting Under A Palm Tree," though small in size, is typical of his delicacy and lyricism.

The vogue of Ovid during this century is particularly well illustrated in the work of Giacomo Franco (born 1566). Mr. Lea's complete set of ten, "Illustrations to the Metamorphoses of Ovid" by Franco, which are exhibited, is extremely rare and shows the freedom and fantasy of the engraving of this period.

Another interesting group is that consisting of the work of the Ghisi family (so-called) of Mantua. Giorgio Ghisi (1520–1582) was the principal member of this school; his prints are bold and forceful in design, reflecting the classical style of Mantegna as well as the line technique of Raimondi, but he is characterized especially for his strong black shadows. His print, "Venus and Adonis," is particularly handsome in composition and richness of shadow. Close imitators were Adam, Diana and Giovanni Battista Ghisi, the real name of this family being, however, Scultori. Prints by each are included.

An example of the limit to which weird fancy could go with the Italian designer—a limit beyond any that painting could reach, in that engraving is always a freer medium for expression—is "The Skeleton with the Sorceress," by Agostino di Musi (flourished 1514–1536). This plate has been variously entitled, but, like many other pictures of the period, bears a variety of interpretations.

We now come to the later Italian School in which the Lea collection is particularly rich. The gifted family of the Carraccis is well represented. We know the Carraccis as religious painters of the grand manner, whose pictures, generally large in scale, were designed as decorations for churches and public buildings. As engravers, they are surprisingly delightful on a small scale, for that skill in drawing for which they are noted makes a strong appeal to us where the forms are constrained to small dimensions. Agostino Carracci is represented by a "St. Jerome," Annibale by a "Christ and St. John" and Ludovico by a "St. Francis." Of this same school is Federigo Baroccio who is a more delicate and individual master than the Carraccis. His "Virgin and Child in the Clouds" is one of only four engravings known to be by him.

The most delightful of the masters of this period represented here is, perhaps, Giovanni Andrea Podestá (born about 1620), whose "Bacchanalian Cupids Playing with Goats" shows that rare abandon to pagan allegory with a free play of fancy and ease of technique which make his prints truly charming. The same idyllic paganism is shown in Della Bella's two prints, "Landscapes with Fawns."

Nearly all these masters were fine draughtsmen. We can only touch upon a few more prints, for example the "Adam and Eve" and "Mercury and Argos" of Simone Cantarini (1612–1648). How perfectly foreshortened is the reclining Adam! How freely exhibited the figures of the "Mercury,"

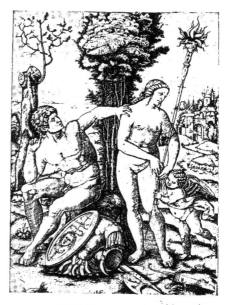

MARS, VENUS AND LOVE
BY ANDREA MANTEGNA

and if we are accused of too much admiration for skilful technique we are justified by Cantarini's poetry.

The Romantic school is illustrated by Salvator Rosa (1615–1673). His "Soldier Tied to a Tree" is typical of his predilection for soldiery, battle scenes and the like. Ribera (1588–1652), like Salvator Rosa, was Neopolitan if also Spanish. He liked to picture hermit saints in prayer and meditation, whose infirmities he rendered with detailed realism, as in the print here shown of "St. Jerome."

The culminating figure of Italian Art is Tiepolo (1696–1770). His two prints "Nymph and Fawn" and "A Cavalier" show his mastery of his medium —perfect freedom from limitations. There is also fine composition and delightful lyricism reminiscent of the early sixteenth century school.

The value of such an exhibition is this; the whole range of Italian Art can be seen at a glance, for prints reflect and express the greater arts of painting and sculpture. Beginning with Mantegna, we see the struggle for expression with hampered technique and hardness of line and of form, and ending with Tiepolo, we see a perfect ease of expression. But it is also proved to us that facility has little to do with art; that the means of expression count for little, provided there is something to express, and Mantegna, Raimondi and the other earlier masters remain great because they were moved by profound emotions.

ARTHUR E. BYE

317

IV. SATIN WEAVES
a, SIMPLE SATIN

Satin is the last of the basic weaves, which we have been considering in their relation to simple and compound textiles. The name is ordinarily understood to mean a silk fabric woven in a certain way; it should, however, refer to the weave and not to the material, and it will be used in that sense only in this classification.

In satin the bulk of the warp—or the bulk of the weft—is on the face of the fabric, and the threads which are visible are usually finer and more numerous than those which are concealed. A warp satin is one in which the warp threads appear on the surface, and a weft satin is one in which only the weft threads appear; in early textiles the weft satin weave occurs only in linen damasks. Satin is closely related to twill, and in weaving satin each weft thread may be passed regularly, but never successively, over one and under five or more warp threads: the first weft thread may, for example, cross over the first warp and under the next six, the second weft over the third warp and under the next six. This produces a smooth surface, since the warp threads are crossed by the wefts at long intervals and the weft is hardly perceptible. In a twill, on the other hand, the warps are crossed by the wefts in sequence, one after the other: the first weft over the first warp, the second weft over the second warp, and the third over the third, so that the float of each weft is set one warp thread to the right or left of the float of the preceding weft. The simile, which we used in our study of twill, of a series of parallel ropes laid vertically on a flight of steps and held down at intervals by stones, is also applicable to satin: the first weighting stone for the rope on the left should be put on the bottom step, and the second stone for the same rope on the eighth step; the first stone for the next rope is on the fifth step (instead of on the second, as in twill); and the weighting of the third rope is on the ninth step. In this way the stones will lie at vertical and horizontal intervals of seven steps, and the lowest stone for each successive rope will be four steps higher than the preceding one. The important difference in structure between satin and twill, therefore, is that in twill the threads intersect on the principle of one step up, while in satin it is two steps up or more. Since satin is woven like twill and sometimes even has diagonal twill lines—although in satin they are more nearly perpendicular—classification is not always easy; some of the doubtful pieces, indeed, have been called "satin twills." In ordinary cases, however, it is simple enough to recognize a satin by the smooth surface and the lack of conspicuous diagonal ribs. Satin weave on the face of a fabric results in twill or cloth weave on the back. The long stretches of uninterrupted thread make satin the ideal weave for silk, and in satin, as M. Algoud so well expresses it, *"la soie peut déployer le plus complètement peut-être les qualités qui lui appartiennent en propre et joindre un éclat miroitant sans rival à une moelleuse et riche épaisseur."*

A plain satin is one without any woven design, although it may have stripes in different colours, and may of course be stamped, printed, or even slashed. Figure 1 shows a fragment of green satin, with a seventeenth century design, which is probably Italian and which has been both stamped and slashed. It was most likely part of a costume, and no doubt was much admired when the vogue for slashing was at its height. In the classification, under the heading simple satin, true damask—which might better be called merely damask—corresponds to the fancy weaves under the other headings, since damask is the only possible variant of plain satin. Damask is a reversible fabric in which the design is formed by a contrast between satin and a twill or a cloth weave (Figures 2, 3): the areas of satin on the face are areas of the contrasting weave on the back, and the areas of the contrasting weave on the face are areas of satin on the back. This effect is produced by reversing the action of the warps so that the satin, as it were, periodically executes an about face and turns first its face and then its back to the onlooker. The essential characteristic of damask, therefore, is that it is reversible. In linen damask tablecloths and napkins the pattern usually appears in weft satin and the background in the contrasting weave. In modern silk damasks either the design or the background may be of satin, but almost all the early examples have a satin ground with the design in the contrasting weave. Most damasks are of one colour only; they may, however, have two colours, one for the warp and consequently for the satin, and one for the weft and the contrasting weave. A piece of green damask, also a fragment from a costume, is illustrated in Figure 2. It is rather unusual, because the tension of the warp threads is greater than that of the weft, which makes a ridge and depresses the areas of satin, bringing those of cloth weave into relief. The design of the green damask in Figure 3 is particularly charming: a conventionalized plant, framed by a large leaf form, grows from a fluted vase; these motives are repeated and framed in branches of fruit, issuing from cornucopiae and surmounted by small crowns; the stems of the cornucopiae join and then magically become the foliage of a pomegranate plant.

b. COMPOUND SATIN

Compound satin includes all fabrics which have any areas of satin weave and which have extra warps or extra wefts, or both. The term damask has been used for compound satins, but this has proved confusing and it therefore seems best to apply the name damask solely to true damasks; the division of compound damasks will then contain only those true damasks which are reversible, but which have an extra weft, usually of metal.

There is a type of compound satin (Figure 8) imitating damask but which has two concealed wefts and is not reversible; the background is of cord weave on both the back and the face of the fabric. This piece is rose colour, brocaded with a gilt thread which has not tarnished in the slightest degree. The design woven in compound satin completes and enriches the brocaded pattern. In many compound satins the extra wefts appear on the surface to form the designs. The pattern in Figure 5, for example, is in the extra yellow

FIGURE 1. SIMPLE SATIN, STAMPED AND CUT—SILK ITALIAN, EARLY 17TH CENTURY

FIGURE 2. DAMASK—SILK, ITALIAN OR SPANISH, EARLY 17TH CENTURY

weft, outlined by the main weft which is brown, on a satin background of taupe colour. Many such narrow designs were woven during the Renaissance, doubtless for borders or for the apparels and orphreys of ecclesiastical vestments. During the fifteenth and sixteenth centuries, orphreys and apparels with religious scenes and emblems were woven of silk and linen compound satin. The example illustrated in Figure 7 has seen hard service as an apparel, but has lost little of its beauty. The subject, in pure Renaissance style, is the Assumption of the Blessed Virgin: Saint Mary, in a glory, is seated on clouds within an almond-shaped frame, supported by four flying angels; below is an open tomb, inscribed "ASUNTA," and from it grow three lilies; at one side kneels Saint Thomas, on whom our Lady is bestowing her girdle. The Girdle of the Madonna was held in great veneration in Tuscany, and the Chapel of the Sacra Cintola was built for it in the Cathedral of Prato, near Florence, abour 1320. Our fragment was probably woven in Florence, and a similiar design has been attributed by Sangiorgi to Ghirlandaio.[1] The background of this piece is red satin; the main weft is heavy pink linen which appears only on the back; the design is in a second weft of yellow silk; and over this there was originally a third weft of gilded goldbeater's skin (thin membrane), wound on a core of linen thread, but only some of it remains. These wefts are bound down by a second warp of fine yellow silk. The compound satin in Figure 6 has also an extra warp: the satin warp is black and forms the background of the design; the second warp is green and does not appear on the face of the fabric; the main weft is green, and the extra weft is white; there is also brocading in many different shades. This panel is French, probably from Lyons,

[1] Giorgio Sangiorgi, *Contributi allo Studio dell' Arte Tessile*, p. 98.

and it was more than likely used as a wall covering. It is a good example of the excellence attained by the craftsmen of the eighteenth century in all that pertains to the technique of weaving.

The origin of satin is unknown. There is even no real knowledge as to the derivation of the name, which has been the centre of much controversy. It may come from the late Latin *seta, setinus,* silk and silken, or from the mediaeval pronunciation of the Chinese word for satin, *ssu-tuan.* There is also good reason to believe that it might have been derived from Zaitun, mentioned by Marco Polo, which was the great port of China in the middle ages and is probably the modern Ch'uang chou. Ibn Batuta, who traveled in the first half of the fourteenth century, writes that a rich silk fabric was made in Zaitun which was called Zaituniya, and the Arabic word that he uses to describe it is *atlas;* this word, in later years, means satin but it is impossible to know whether Batuta used it in that sense or not. It has been said that in mediaeval Italian satin was *zetani raso,* and in mediaeval Spanish *azeituni;* in England the word is used by Chaucer,

"I wil give hym a feder bedde
Rayed with golde, and ryght wel cledde
In fyne blak satyn de outer mere."
—*The Dethe of Blaunche the Duchesse*

and it also appears in France in the fourteenth century, but again one cannot be sure what kind of fabric was meant by these terms. It seems likely that both the name and the weave are of Chinese origin—the weave could certainly have been developed in China from the Han silks, in which a smooth glossy surface is produced by the warp threads which form both design and background—but nothing can be proved.

Fabrics of satin weave are not found in the West before the fourteenth century, or perhaps the late thirteenth, although there are many warp twills of earlier date which are constantly called satins. Satin may have been developed in the West from the earlier herring-bone or other irregular warp twills, or it may have been brought from the Far East. It is interesting to find that both the name and the weave appear in Europe during the period of Chinese influence in textile designing. No Chinese patterned silks which are earlier than the fourteenth century seem to have been preserved in Europe. After 1300, however, Chinese designs came to Europe both in Far Eastern fabrics, many of which still exist in various European countries, and also indirectly through Persian designs. The infiltration of Chinese motives at this time was the result of the conquests of the Mongols. In the thirteenth century, under Genghis Khan and his descendants, the Mongols spread their dominion all across Asia from China into Europe, and they even ravaged parts of Hungary and Poland. Hulagu, grandson of Genghis Khan, was the first Mongol sovereign of Persia, and in his kingdom there were many Chinese; at the court of his brother Kublai Khan in Peking, there were many strangers from the West—from Persia, Byzantium, France, and Venice, as we know from the writings of Marco Polo—and this far-flung Mongol Empire resulted in greatly increased

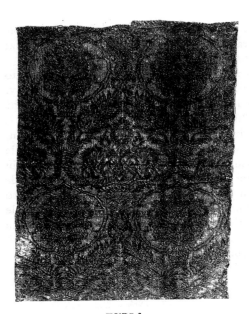

FIGURE 3.
DAMASK—SILK. ITALIAN, LATE 15TH CENTURY.

trade and more frequent communication between Europe and the Far East. The power of the Mongols was such that alliances with them were sought by the Emperors of Byzantium and by other Western rulers. The son of Hulagu married a daughter of Michael Paleologus; Toktu Khan, ruler of the Golden Horde, married a daughter of Andronicus II, and his successor, Uzbeg Khan, married a daughter of Andronicus III; the Sultan of Egypt, Malik al-Nasir, married a daughter of Uzbeg Khan, and another daughter was married to George, the Prince of Moscow. These intermarriages and the records of embassies exchanged between the European and Far Eastern powers bring vividly to mind the close connection that existed between Orient and Occident in the fourteenth century, and we are no longer surprised to find that Italian and German vestments were made of Chinese brocaded silks, and that the textile designs of this period in Italy were revolutionized by the influence of Chinese patterns.

The satins of the fourteenth century may be Simple, with a design of brocading, or else Compound, with the pattern in an extra weft of gilt thread or coloured silk or both. Orphreys of silk and linen compound satin, as illustrated in Figure 7, were produced in considerable quantities during the fifteenth and sixteenth centuries. This weave was adopted for secular designs in the sixteenth century, and was also widely used in the seventeenth, but after that time it is rare. In these fabrics the background may be of satin weave, or the design may be satin.

Many silk and linen compound satins are known in the trade as *brocatelles*, but there are good reasons for omitting this word from a system of classification by weaves. In the first place, its meaning varies to such an extent that it is difficult to determine what type of fabric it denotes. A comparison of some of the definitions emphasizes this fact. "Fabric of silk and cotton, imitating brocade" (Hatzfeld and Darmesteter, *Dictionnaire Général de la Langue Française*); "An inferior material used for curtains, furniture-covering, and the like, made of silk and wool, silk and cotton, or pure wool, but having a more or less silky surface" (Century Dictionary); "A damask in which the design, made by the warp, is in raised satin weave on a background made by the weft in twill weave.

The linen weft thread is used to emboss the ground and to heighten the relief. Two warps, one for the binding; three harnesses" (Pariset, *Les Industries de la Soie*); "In the seventeenth century, brocatelle was usually of silk and cotton in a single colour, with damask designs of large flowers, and it was woven more especially in Italy; owing to the difference in materials the design appears in relief" (Heiden, *Handwörterbuch der Textilkunde*); "Ordinarily a linen weft forms the ground, while the warp is of silk, although there were also brocatelles entirely of silk, or of wool, or of cotton"

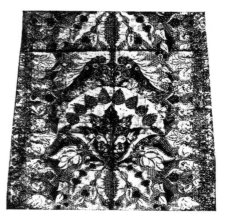

FIGURE 4. COMPOUND SATIN, BROCADED—SILK. PROBABLY ITALIAN, LATE 17TH CENTURY.

(Bezon, *Dictionnaire Général des Tissus*). There are similar definitions in various textile dictionaries, but they do not supply any more definite information, nor do they agree as to the meaning of brocatelle. Another reason for discarding the word is that it implies a combination of silk with some other material, and that precludes its use in classifying by weaves only, although it may well serve in other connections to designate a certain type of fabric.

The word lampas has been abandoned for the same reasons. It is variously defined as: "Originally, East Indian painted silk fabrics, which came to Europe through Holland—at present, rich patterned silk stuffs for furniture-covering, hangings, church vestments, and such like" (Heiden, *Handwörterbuch der Textilkunde*); "Silk fabric from China with large designs on a background of a different colour" (Littré, *Dictionnaire de la Langue Française*); "Originally Chinese flowered silk—hence, in modern times, a material of decorative character for upholstery, made of silk and wool" (Century Dictionary); "A fabric of Indian lampas, silver and silk, which seems to be woven with both the brocading bobbin and the ordinary shuttle" (Michel, *Recherches sur les Etoffes*); "A damask in which the design, of taffeta, is raised on a satin ground which is of a different colour—two warps, four harnesses" (Pariset, *Les Industries de la Soie*). The term does not seem to have been used before the eighteenth century, and it then probably referred to a type of compound satin, woven as M. Pariset describes, which was produced in quantities during the Louis XVI period; these compound satins give the effect of a two-colour damask, but they have two warps and two wefts and are not reversible.

Silk damasks began to be plentiful in the fifteenth century, although they also occurred in the fourteenth; linen damasks did not appear until the sixteenth century, and they were not woven in any quantity before the seventeenth. The word damask is taken from the city of Damascus where rich fabrics were made in the early days; it is quite unlikely, however, that they were of the

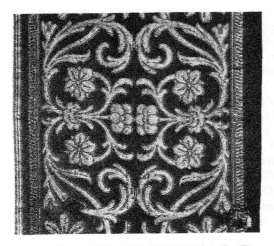

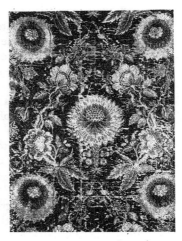

FIGURE 5. COMPOUND SATIN—SILK. ITALIAN, LATE 16TH CENTURY.

FIGURE 6. COMPOUND SATIN, BROCADED—SILK. FRENCH, EARLY 18TH CENTURY.

same weave as the textiles known today by that name. Many of the later fifteenth century patterned stuffs were damasks, and this weave has continued in use until the present day.

The all silk compound satins of the sixteenth and earlier seventeenth centuries usually have designs in two wefts, somewhat loosely woven, on a satin ground (Figure 5). In European weaving of the later seventeenth century, particularly Italian fabrics, we find, in addition to the richly brocaded Italian damasks of the same period, the new compound satin weave which imitates damask but is not reversible (Figures 4, 8). The most elaborate examples of this weave are in some of the large symmetrical designs of fantastic, luxuriant foliage—although not all of these are in the same weave—which are attributed to the late seventeenth or early eighteenth century. These silks may be distinguished from the earlier compound satins by the fact that only one of the wefts is loosely woven and appears on the surface, while the other is tightly woven to imitate the contrasting weave of damask (Figure 4).

A type of satin which originated in the Louis XIV period appears in Figure 6. In this piece the satin warp is backed with a second invisible warp which is interwoven with the main weft. One might say that these fabrics are in two layers, and when the satin layer is worn away, the foundation or strengthening layer appears beneath it. The popularity of satin and damask waned in the Louis XV period, when taffeta and cord weaves prevailed, but these fabrics returned to favor in the reign of Louis XVI. Since that time the number and variety of satins have steadily increased, and the weave has been used more and more for other materials than silk.

An elaborate patterned satin is one of the crowning achievements of the art of weaving. It is the weave which above all others especially demands

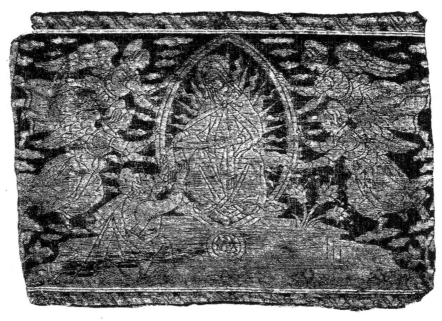

FIGURE 7, "THE ASSUMPTION."
COMPOUND SATIN—SILK AND. LINEN. ITALIAN, 15TH–16TH CENTURY.

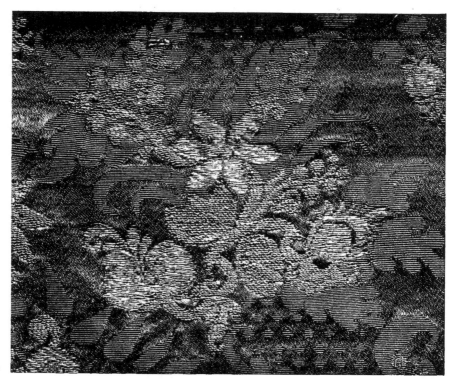

FIGURE 8.
COMPOUND SATIN, BROCADED—SILK. ITALIAN, 17TH–18TH CENTURY.

expert spinning, warping, and weaving, as the slightest flaw will ruin the fabric. The history of weaving, with all its difficulties and triumphs, is summed up in the Persian proverb quoted by Henri Cantel: *"Avec du temps et de la patience la feuille du mûrier devient satin*—Time and patience at length convert into satin the leaf of the mulberry tree." NANCY ANDREWS REATH

NOTES

MOUNT PLEASANT. The exhibition at Mount Pleasant, American art on the eve of the Revolution, will be continued open throughout the year, at the same hours as heretofore. Daily 9.30 A. M. to 5 P. M.; Sunday 1 P. M. to 5 P. M. The Museum will continue the administration of the house as a permanent addition to its facilities.

PUBLICATIONS. Photographic copies of all objects belonging to the Museum are made by the staff photographer, and may be obtained at the information desk; in cases where negatives are not already in the files, orders will be taken and executed as promptly as possible. Individual postal cards and series of postal cards of the collections are published by the Museum. The publications in print include handbooks of collections, special exhibitions, and catalogues of various departments. The monthly illustrated BULLETIN is sent free to members, and to others $2.00 a year, or 25 cents per copy.

MUSEUM LIBRARY. The reference library of the Museum contains books and periodicals on art and related subjects, which are at the free disposal of the public for consultation. The Librarian will give any assistance desired. Open from 9.30 A. M. to 4 P. M.; Saturdays from 9.30 A. M. to 12.30 P. M.; closed Sundays, Mondays, and holidays.

ADMITTANCE. The Museum is open free to the public every day except Mondays. Summer hours: Sunday, from 1 P. M. to 5 P. M.; other days, 9.30 A. M. to 5 P. M. Winter hours: Sunday, from 1.30 P. M. to 4.30 P. M.; other days, 9.30 A. M. to one hour before sunset.

COVER ILLUSTRATION. Portraits of Marc Antonio Raimondi and Albert Dürer, by Marc Antonio Raimondi after Dürer, from the exhibition of early Italian engravings, lent by MR. and MRS. CHARLES M. LEA, now on view at the Museum.

PRINCIPAL ADDITIONS TO THE MUSEUM LIBRARY
BOOKS ADDED BY PURCHASE

AUTHOR	TITLE
Binyon, Laurence	Chinese Paintings in English Collections
Champier, Victor	Le Mobilier Flamand
	Deutsche Volkskunst Vols. 2 and 3
Diez, Dr. Ernst	Die Kunst Indiens
Dreyfus	Le Mobilier Français, Louis XIV to XV
	Le Mobilier Français, Louis XV
Dumonthier, E.	Le Mobilier Louis XVI
Germain, Alphonse	Le Mobilier Bressan
Hirn, Yrjo	The Origins of Art
Hobson, R. L.	The George Eumorfopoulos Collection of Chinese, Corean, and Persian Pottery and Porcelain, vol. 3
Kurth, Betty	Die Deutchen Bildteppiche des Mittelalters
Le Couteur, J. D.	English Mediaeval Stained Glass
Paxon, Henry D.	Where Pennsylvania History Began
Read, Herbert	English Stained Glass
Sluyterman, K.	Alte Innenraume in Belgien
	Artibus Asiæ, 1927, vol. 1
Stewart, Basil	Japanese Colour-Prints

CALENDAR OF LECTURES
At the School, Broad and Pine Streets

THESE LECTURES ARE FREE TO MEMBERS OF THE CORPORATION. THE FEE TO OTHERS IS $10 FOR THE COURSE. CARDS OF ADMISSION WILL BE ISSUED ON APPLICATION.

THE ELEMENTS OF ARCHITECTURE FOR INTERIOR DECORATORS
Illustrated by Lantern Slides
BY J. FRANK COPELAND
LECTURES ON THURSDAYS AT ELEVEN A. M.
(APRIL 7 OMITTED)

Feb. 3 The classic entablature.
10–17 The orders.
24 Gothic columns and piers: other types.
Mar. 3 Parapets and balustrades.
10 Stairways and fireplaces.
17 Floor and wall coverings: hangings.

Mar. 24 Lighting fixtures.
31 The choice and placing of furniture, bric-a-brac, etc.
Apr. 14 Decorative sculpture.
21 Decorative painting.
28 Ecclesiastical forms.

FURNITURE: ITS HISTORIC DEVELOPMENT
ILLUSTRATED BY LANTERN SLIDES, CHARTS AND OBJECTS IN THE MUSEUM
BY EDWARD WARWICK
LECTURES ON WEDNESDAYS AT ELEVEN A. M.

NOTE:—These lectures are repeated on Wednesday Evenings at 7.30.

Jan. 26 France. Style of Louis XIV.
Feb. 2 France. The changes under Louis XV.
9 France. Development under Louis XVI.
16 The Brothers Adam.
23 The furniture in the Heppelwhite style.

Mar. 2 The furniture in the Sheraton style.
9 The period of the Empire.
16 Study in the assembling of period styles.
23 Recapitulation.

* These dates are subject to change.

HISTORY OF COSTUME AND ARMOR
ILLUSTRATED BY LANTERN SLIDES, CHARTS AND PHOTOGRAPHS
BY EDWARD WARWICK
LECTURES ON MONDAYS AT ELEVEN A. M.

NOTE:—These lectures are repeated on Monday Evenings at 7.30.

Feb. 7 17th Century. Costume in England and America.
14 17th Century. Costume in France.
21 18th Century. Costume in England and America.

Feb. 28 18th Century. Costume in France.
Mar. 7 Drapery in costume.
14 Ancient ships.
21 Heraldry.

* These dates are subject to change.

ACCESSIONS AND LOANS RECEIVED BY THE MUSEUM
DECEMBER 1, 1926, TO JANUARY 1, 1927

CLASS	OBJECT	SOURCE
CERAMICS	Pottery jar. Chinese, 3000–2000 B. C.	Given by Horace H. F. Jayne in the name of the Fogg Art Museum.
	Pottery figure of a doe. Bennington Ware. American, c. 1850.	Given by Mrs. Hampton L. Carson.
FURNITURE	Mirror, carved frame in Adam style. American, 18th century.	Purchased from Temple Fund.

327

GLASS........Saddle-bag whiskey bottle. American. Given by Clarence W. Brazer.
PRINTS........Four etchings. Given by Arthur Edwin Bye.
 One wood cut.
 One lithograph.
TEXTILES.....Silk square. Persian, 19th century, with 17th Given by Mrs. Edward Browning.
 century border.
 Silk square. Persian (?), 19th century, with
 cashmere border.
 Square of printed cotton. Indian, late 18th
 century.
 Quilted underskirt. American (?), 18th century. Given by Miss Elizabeth D.
 Satin waistcoat. American (?), c. 1800. Hacker.
 Satin slipper, with label "Ebenr Breed, Maker,
 Philadelphia," 18th century.
 Cape of darned net. American, c. 1835. Given by Mrs. Dwight Robinson.

NEW MEMBERS

Since the last report, two Fellow for Life members, one Sustaining member, one Contributing member and fifty-six Annual members have been added to the membership roll.

FELLOW FOR LIFE
Laura Stroud Ladd
Ellen McMurtrie

SUSTAINING MEMBER
Mr. Isaac H. Clothier, Jr.

CONTRIBUTING MEMBER
Mr. Richard Lewis Quinn

ANNUAL MEMBERS

Mr. Walter C. Bailey
Mr. Edward Billett
Rev. James M. Bourne
Rev. W. T. Brady
Mr. Walter Brown
Mr. J. Brooke Buckley
Mr. Frank Burwell
Miss Theodora Philips Bush
Mrs. Charles W. Butler
Mr. C. B. Cooke, Sr.
Mr. Thomas Creighton, Sr.
Miss Margaret deC. Cruice
Rev. John C. Daniel
Mr. Frank E. DeLong
Mr. Lewis C. Dick
Miss Helen Morris Duffield
Dr. Wm. Middleton Fine
Mrs. Ephriam Tomlinson Gill
Mr. E. A. Gruver
Dr. Frank B. Gummey
Mr. Walter G. Herbert

Mrs. Stefano Hickey
Mrs. Thomas Leiper Hodge
Mrs. George G. Hood
Mr. Edward Hopkinson, Jr.
Mr. Henry Howson
Mr. W. F. Killhour, Jr.
Dr. Frank Crozer Knowles
Mr. Harry E. Kohn
Miss Rena Kurth
Mrs. Edmund J. Lee
Mrs. Elisha Lee
Dr. C. B. Longenecker
Mr. Herbert S. Loveman
Dr. Robert M. Lukens
Mr. J. B. MacKenzie
Rev. Henry G. Maeder
Dr. Jacob S. Makler
Miss Margaret C. Maule
Rev. John Edward McCann
Mr. Logan W. Neal
Miss Lillian E. Padley

Mr. Jacob Palsir
Mr. Salvatore Paolini
Miss Elizabeth T. Pearson
Miss Laura T. Pennington
Dr. J. Vincent Penza
Mrs. Austin M. Purves
Rev. F. Elwood Raub
Dr. I. Ravdin
Mrs. John L. Redman
Mr. M. H. Rothe
Dr. Maurice M. Rothman
Mr. John S. Schwacke
Mr. Joseph K. Seidle
Dr. H. Maris Shearer
Mrs. William T. Shoemaker
Mr. Charles C. Shoyer
Mr. William W. Sketchley
Mr. John R. Smith
Mrs. A. L. Stout
Mr. John E. Twining, Sr.
Mrs. L. W. T. Waller, Jr.

Dr. William G. Walton Mrs. William White

OTHER DONATIONS TO THE MEMBERSHIP FUND
Dr. Max Cohen
Dr. W. N. Johnson

MEMBERSHIP

Benefactors in Perpetuity, who contribute or bequeath $25,000 or more to the Corporation.

Patrons in Perpetuity, who contribute or bequeath $5,000 to the Corporation.

Fellows for Life, who contribute $1,000 at one time.

Life Members, who contribute $300 at one time.

Fellows, who contribute $250 a year.

Sustaining Members, who contribute $100 a year.

Contributing Members, who contribute $25 a year.

Annual Members, who contribute $10 a year.

Fellows or Sustaining Members whose contributions aggregate $1,000 may be elected Fellows for Life.

Benefactors, Patrons, Fellows for Life and Life Members shall not be liable to annual dues.

PRIVILEGES

All members are entitled to the following benefits:

The right to vote and transact business at the Annual Meeting.

Invitations to all general receptions and exhibitions held at the Museum and the School.

Free access to the Museum and School Libraries.

Admission to the following Illustrated Lectures:

Twenty-six Lectures on THE ELEMENTS OF ARCHITECTURE FOR INTERIOR DECORATORS, given by J. Frank Copeland, on Thursday at 11 o'clock, beginning in October.

Twenty-three Lectures on FURNITURE: ITS HISTORIC DEVELOPMENT, given by Edward Warwick, on Wednesday morning at 11 o'clock and Wednesday evening at 7.30 o'clock, beginning in September.

Twenty-seven Lectures on HISTORY OF COSTUME AND ARMOUR, given by Edward Warwick, on Monday at 11 o'clock and Monday evening at 7.30 o'clock, beginning in September.

Also a copy of each of the following publications:

Illustrated Monthly BULLETIN of the Museum.

Annual Report of the Corporation.

Annual Circulars of the School.

Art Handbooks and Art Primers, issued from time to time by the Museum.

(A printed list of publications will be mailed to any member on application.)

A list of members is published each year in the Annual Report. All persons who are in sympathy with the work of the institution will be cordially welcomed as members.

Applications for membership, and remittances should be sent to the Secretary, Charles H. Winslow, at the School, Broad and Pine Streets, Philadelphia.

CHANGE OF ADDRESS: In order to facilitate the prompt delivery of mail, members are earnestly requested to send notification of any change of address to the Secretary, Broad and Pine Streets, Philadelphia.